AN ANTIC ALPHABET OF TRICKY TONGUE TWISTERS

A coloring book

Written by Ruth Veres
Illustrated by Peter Veres
©2017

We dedicate this book
to our granddaughters Mika and Camden –
we hope you are not too old to color the pictures.

And we thank our estimable outside consultants
Jacque Giuffre and Paul Veres
for their comments and suggestions.

Ample Annie asked an auk about an anchor.

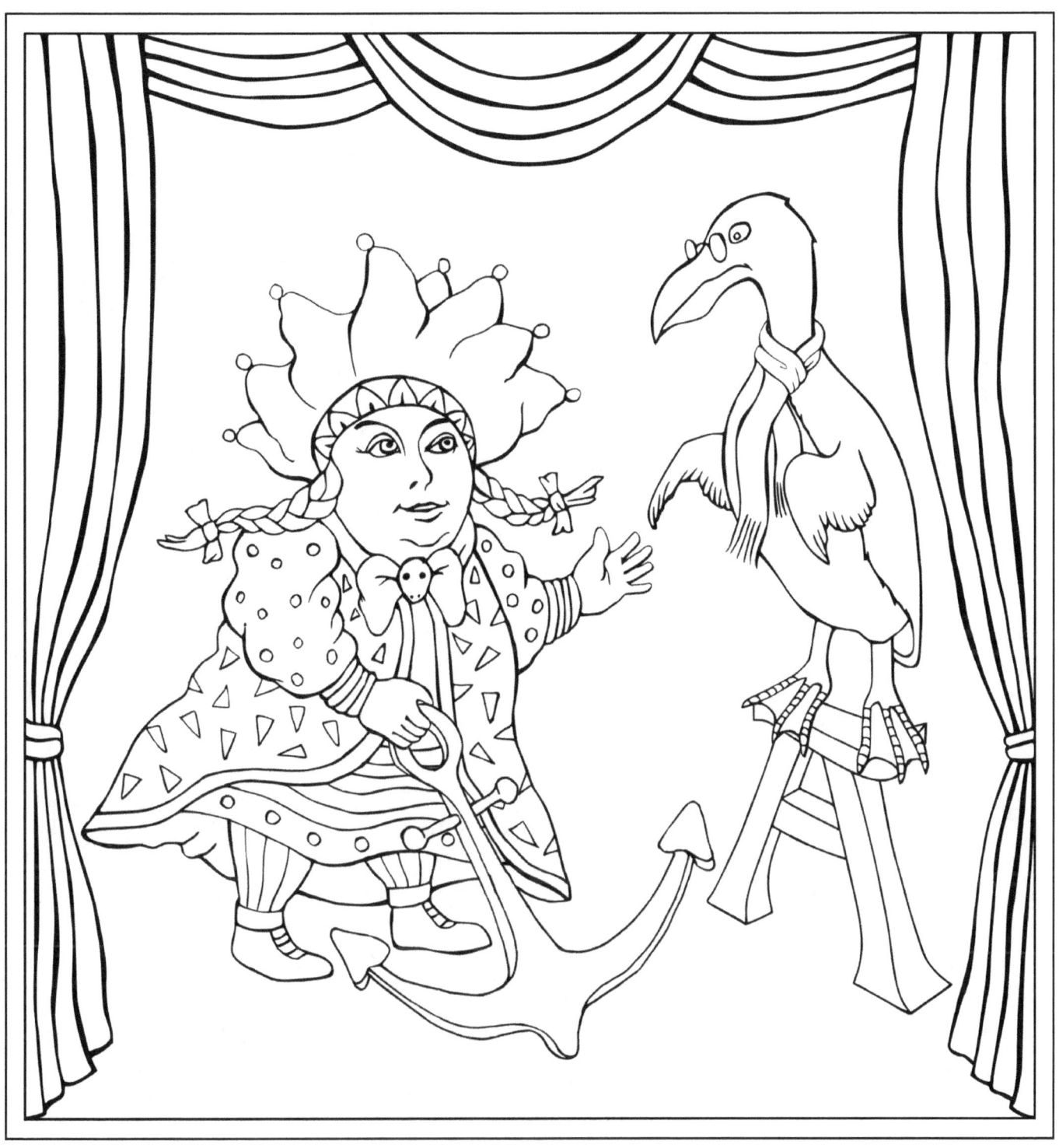

auk : a diving sea bird with short wings, chunky body, and webbed feet

Bearded Benny bagged a bunch of bulging bullfrogs.

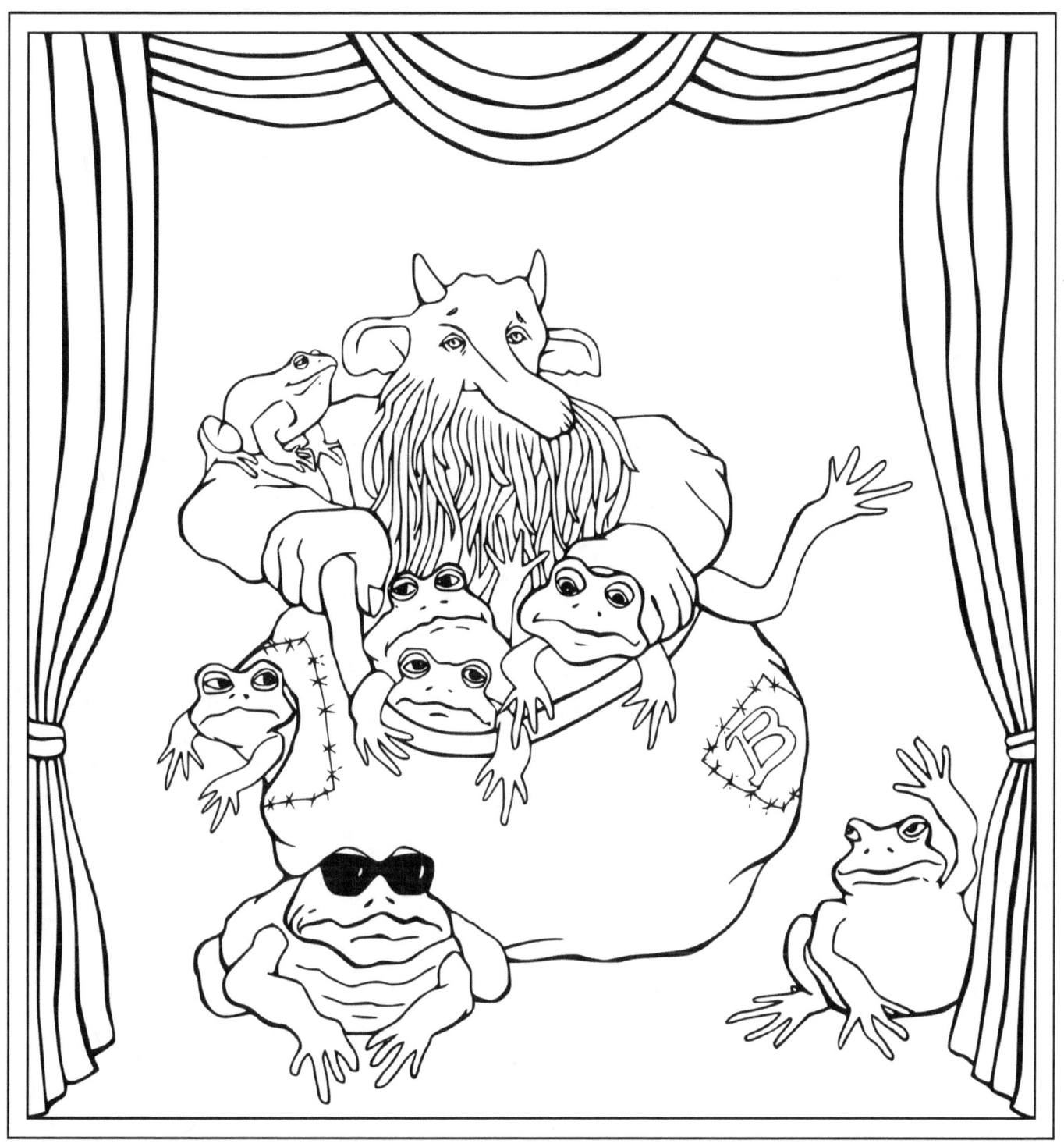

Charming Charlie chomped a chunk of chewy chocolate.

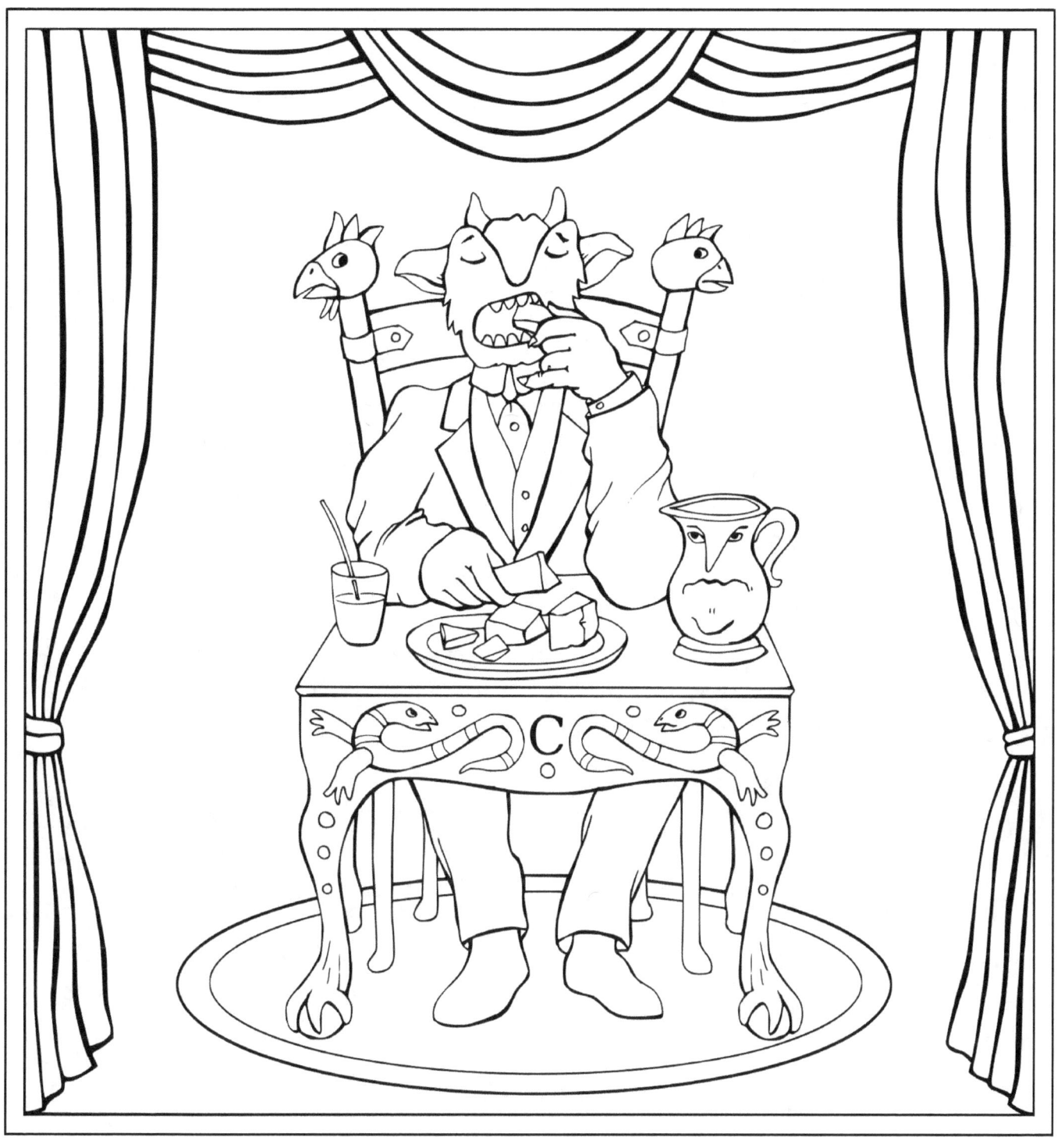

Daring Dottie doused a dozen dancing dik-diks.

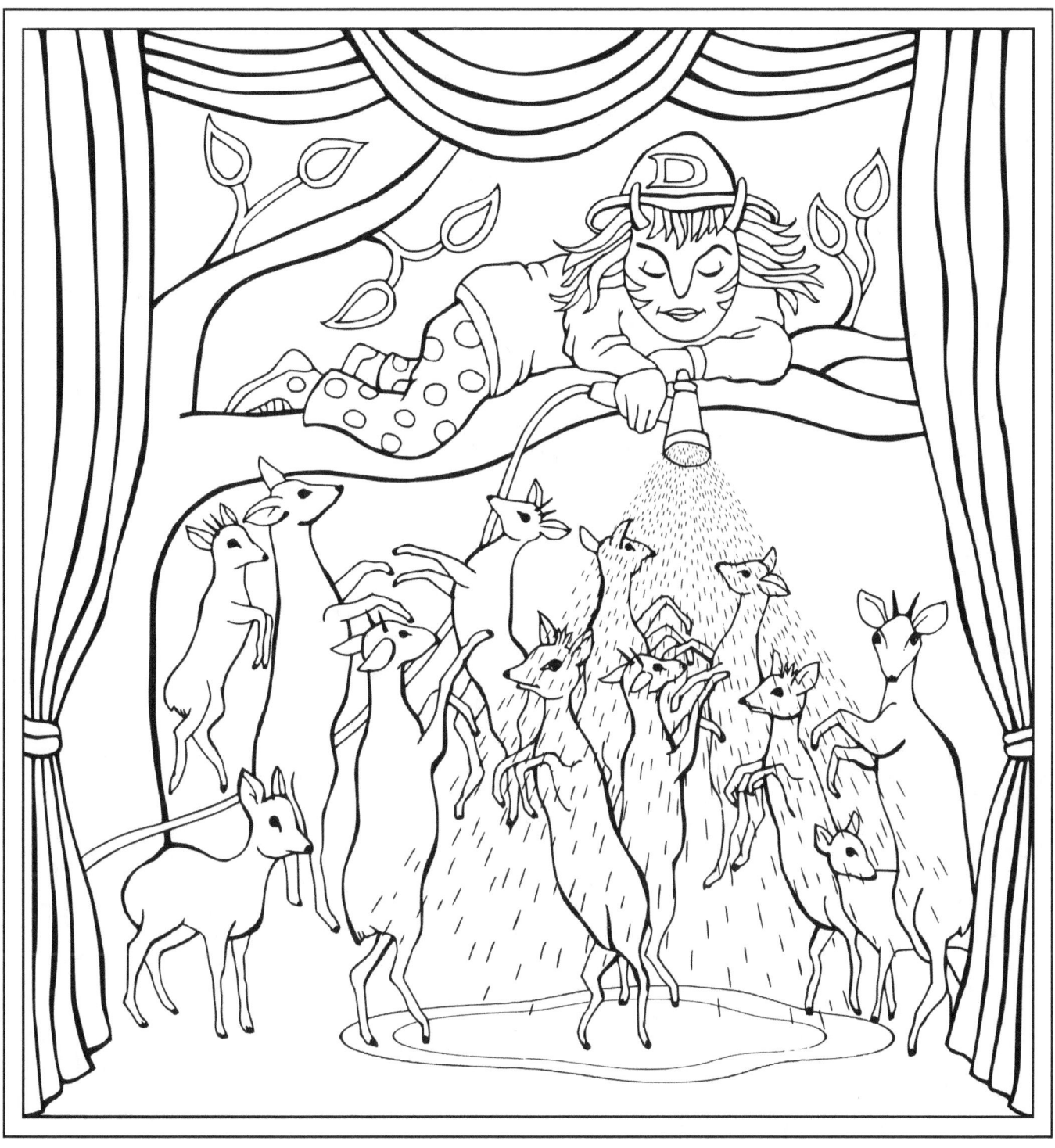

douse : wet thoroughly, drench, soak
dik-diks : small African antelopes

Eager Eric eyed eleven edgy egrets.

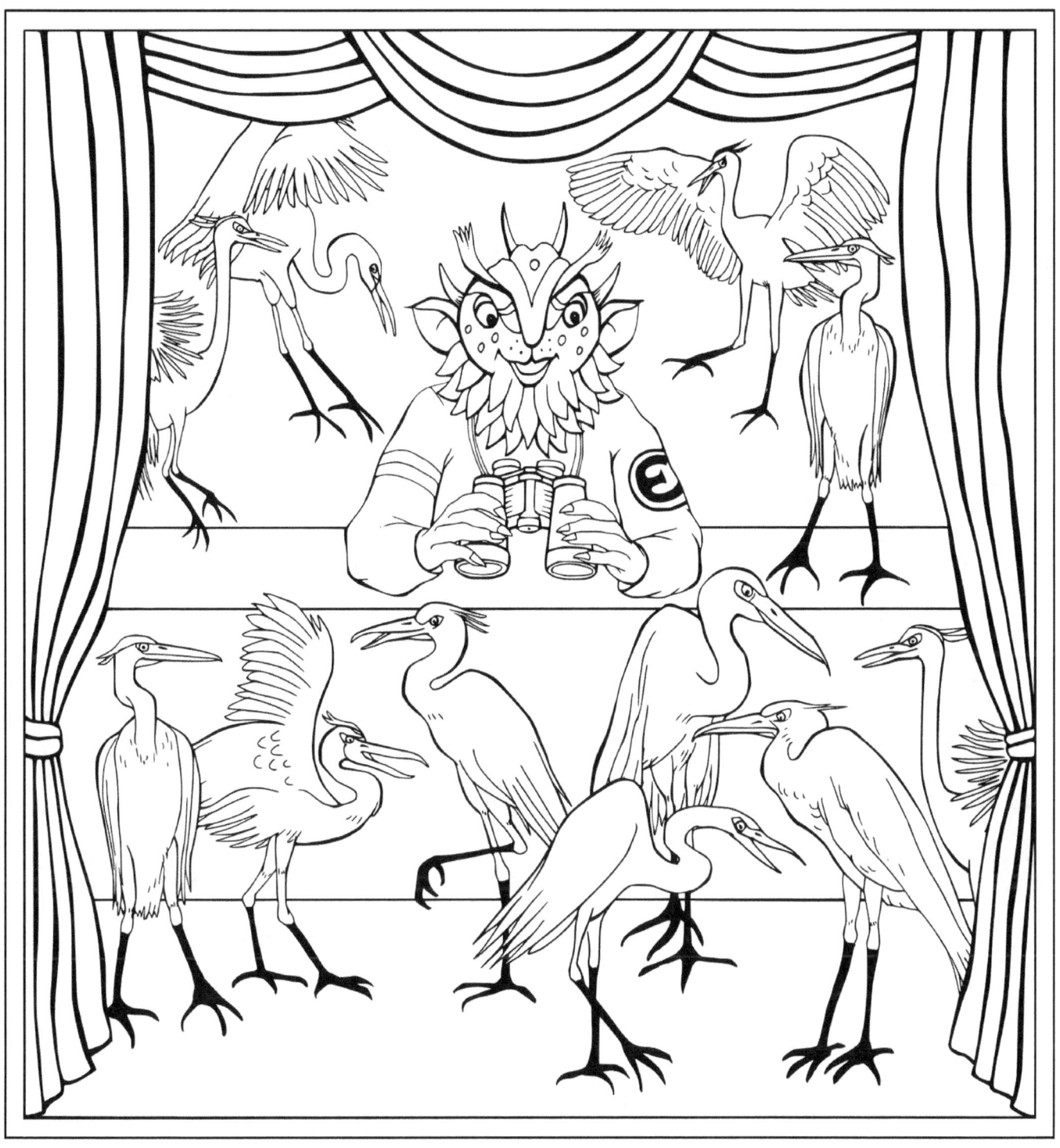

edgy : tense, nervous, irritable
egret : large, white heron with a long neck and yellow bill

Freckled Freddie fled a flock of fearsome ferrets.

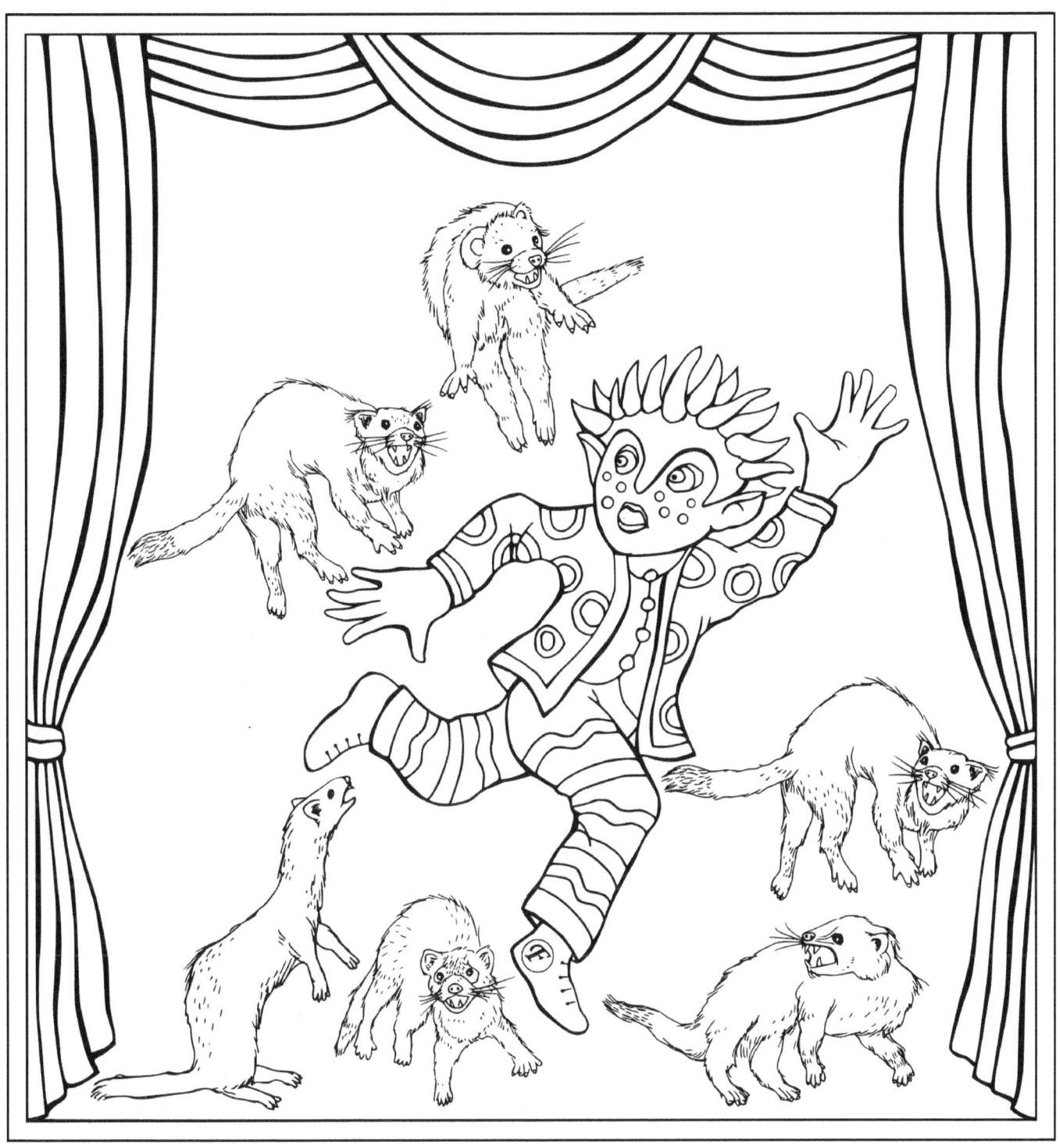

ferrets : weasel-like animals with a long tail and furry, pear-shaped body

Grouchy Gretchen grabbed a group of groggy grouses.

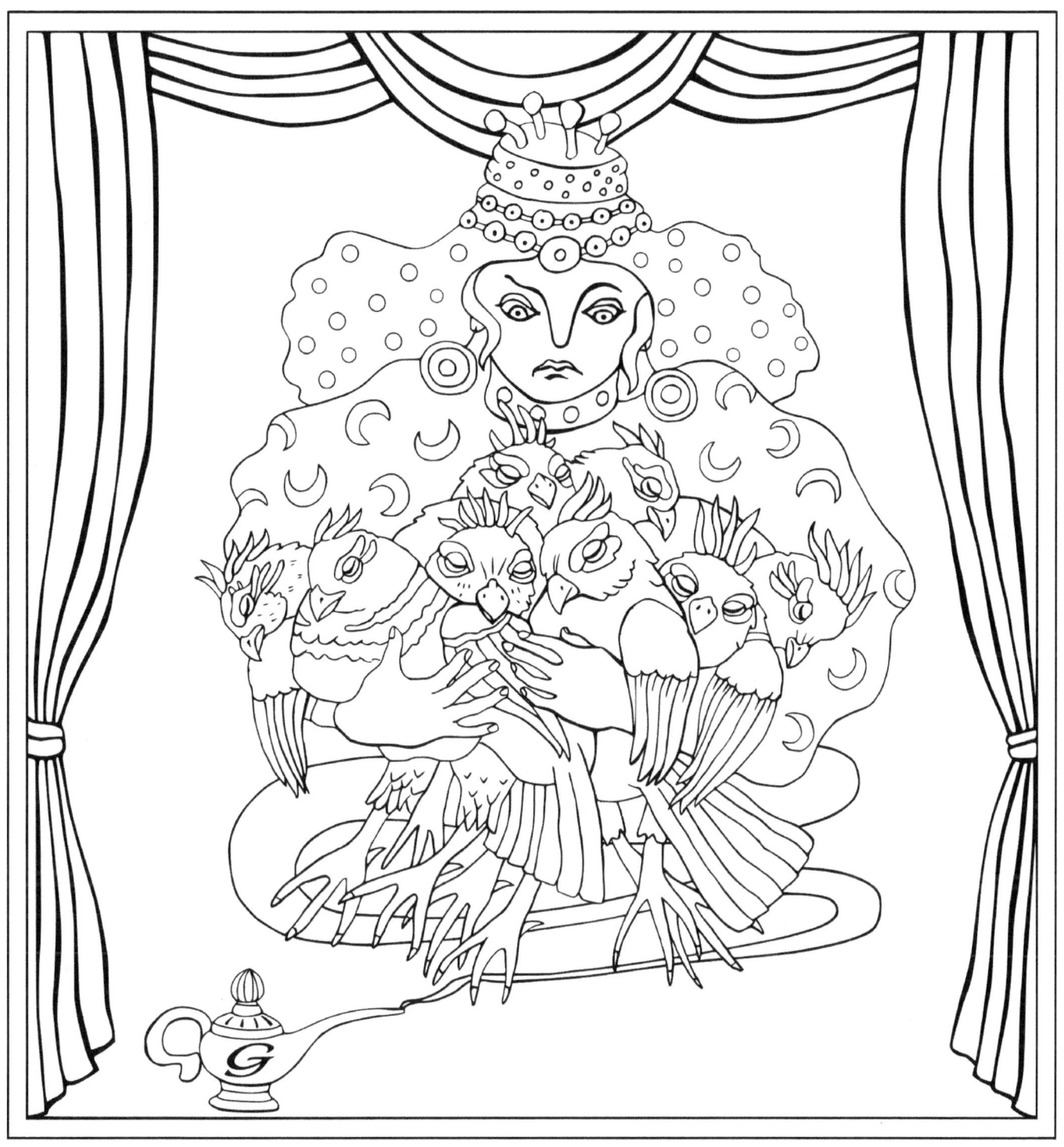

grouses : plump, chicken-like birds with mottled brown or grey feathers

Handy Harry hung a heap of howling hats.

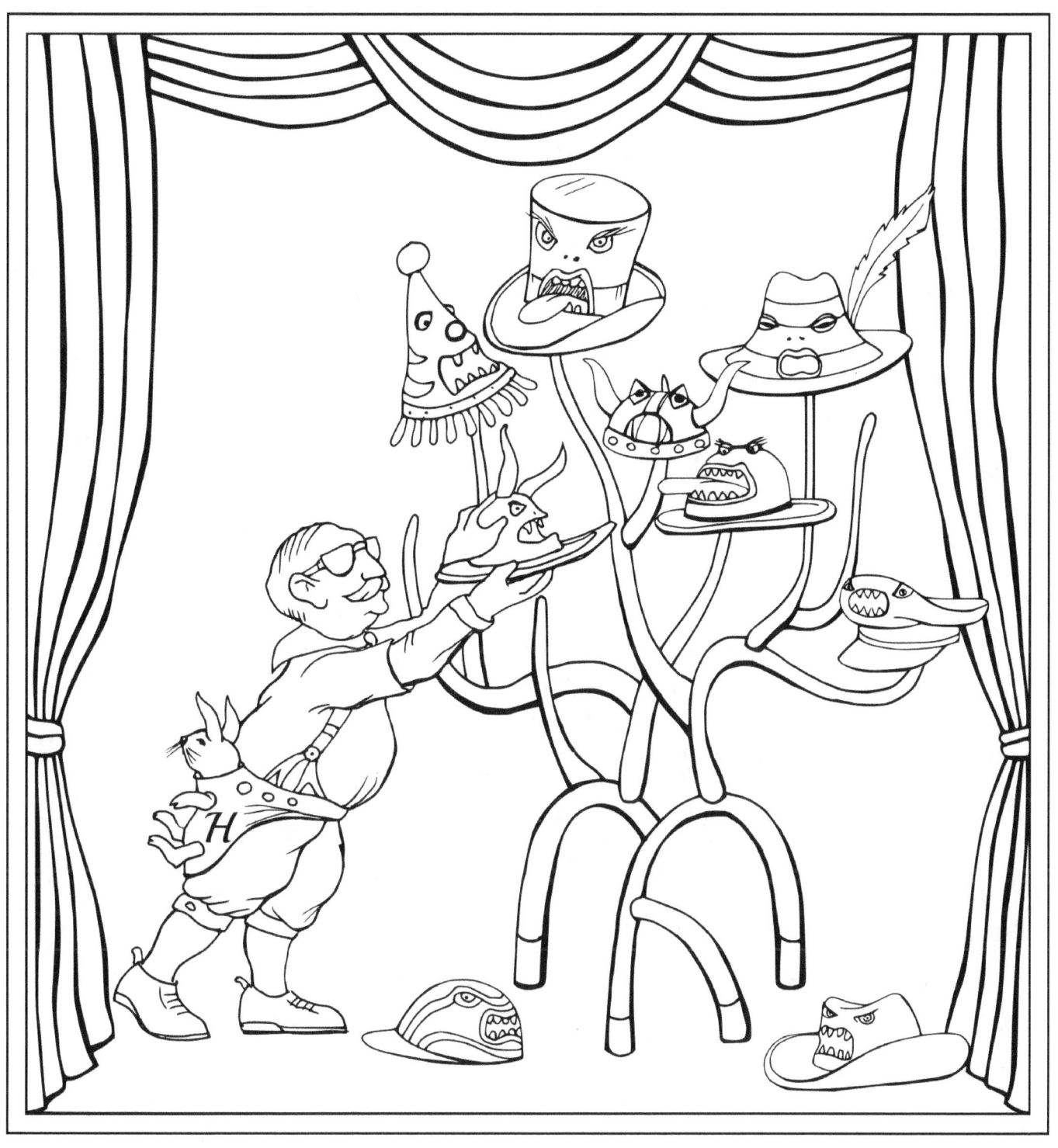

Impish Ida irked an intricate iguana.

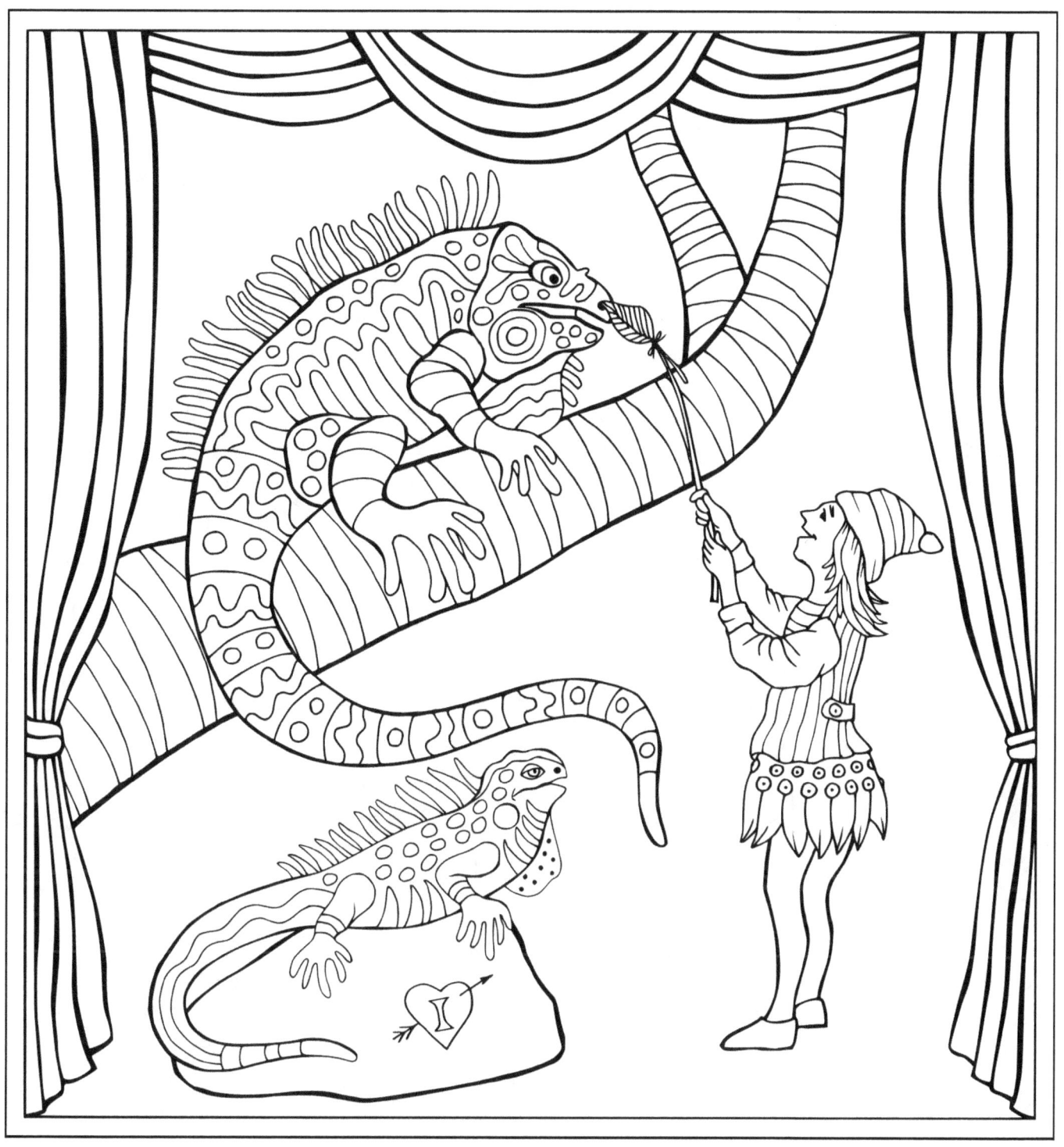

intricate : complicated and detailed

iguana : a large omnivorous lizard that lives in Mexico, Central America, the Caribbean, and South America. It has a spiny crest along its back and comes in a range of changeable colors.

Jolly Julie joined a jig of jousting jugglers.

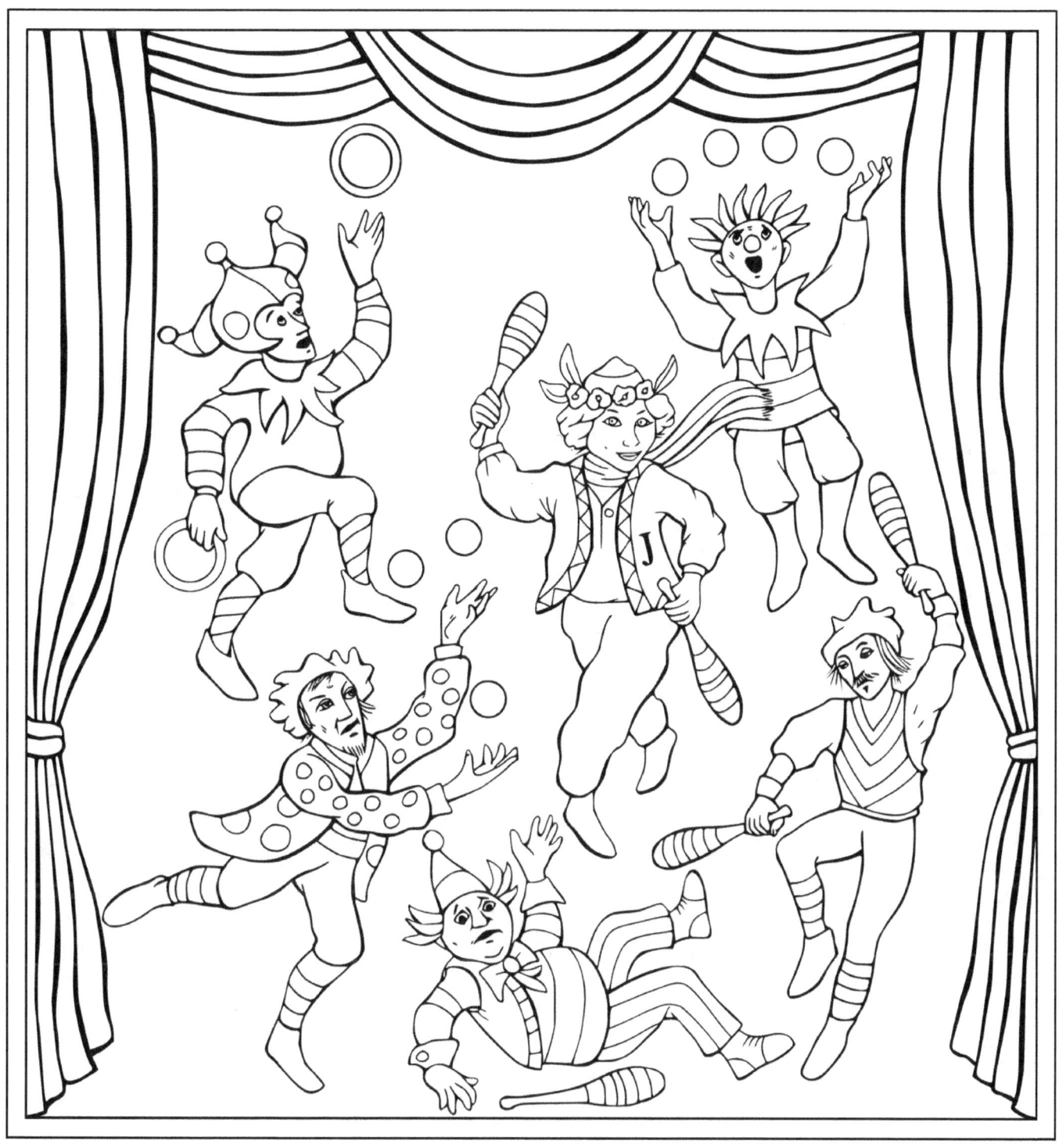

jig : a lively, springy dance with leaping movements
jousting : competing in a contest

Kilted Kenny kicked a keg of kitty kibble.

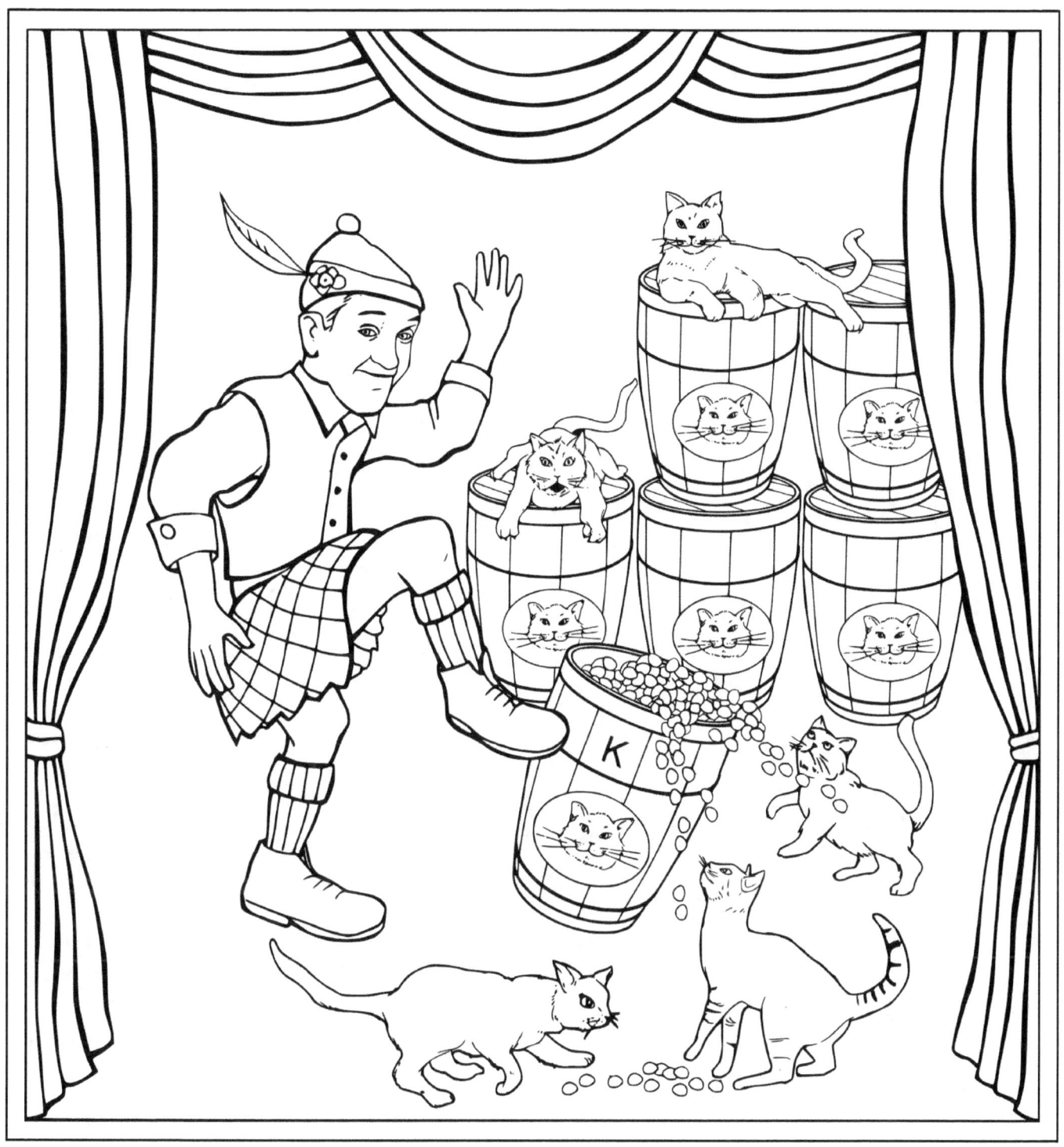

kilted : dressed in a knee-length pleated skirt of the kind worn by men in the Scottish Highlands
keg : a small barrel

Lanky Lisa lugged a load of lazy lizards.

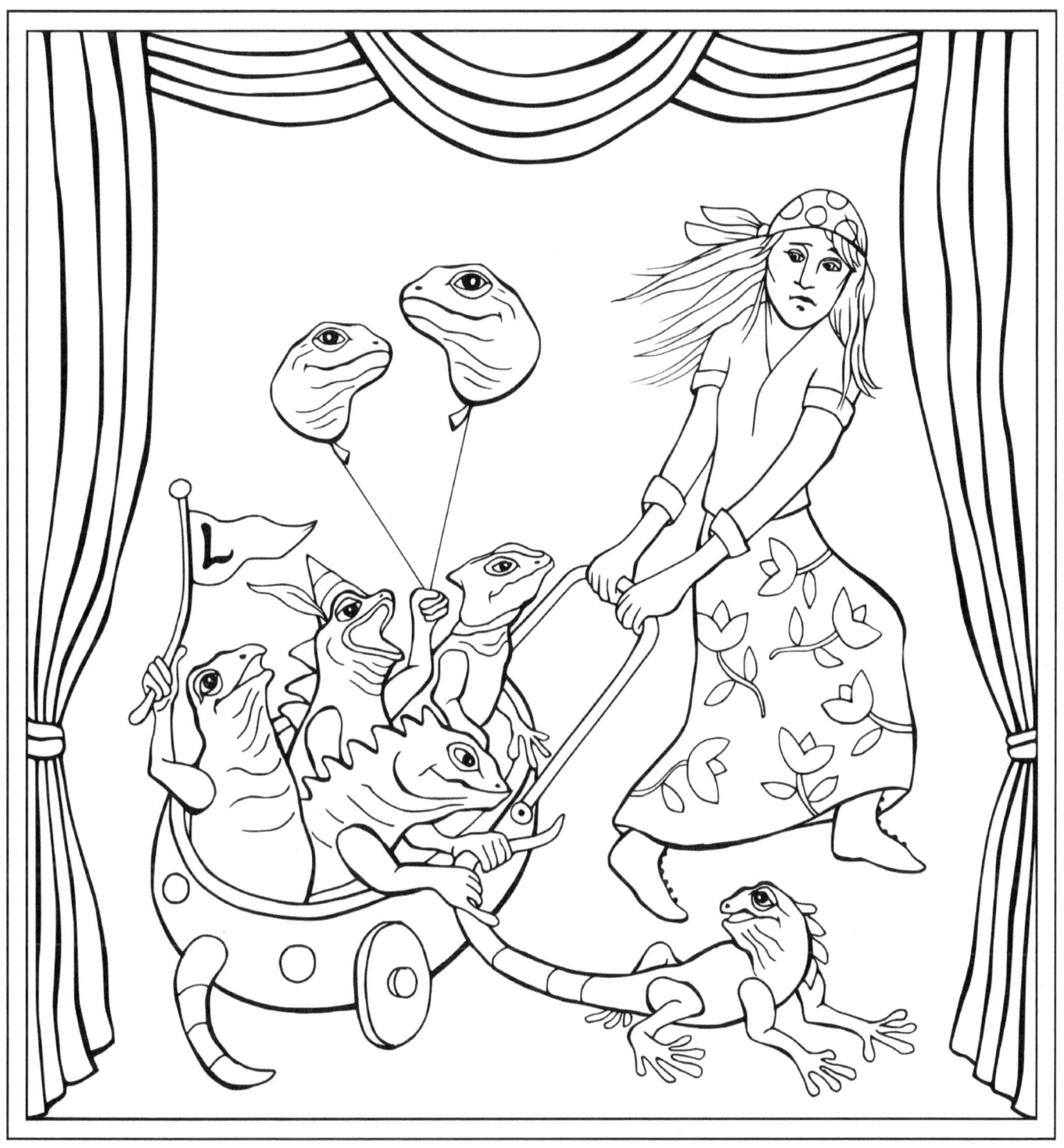

lanky : tall and thin with a touch of awkwardness

Messy Maia munched a mound of mellow melons.

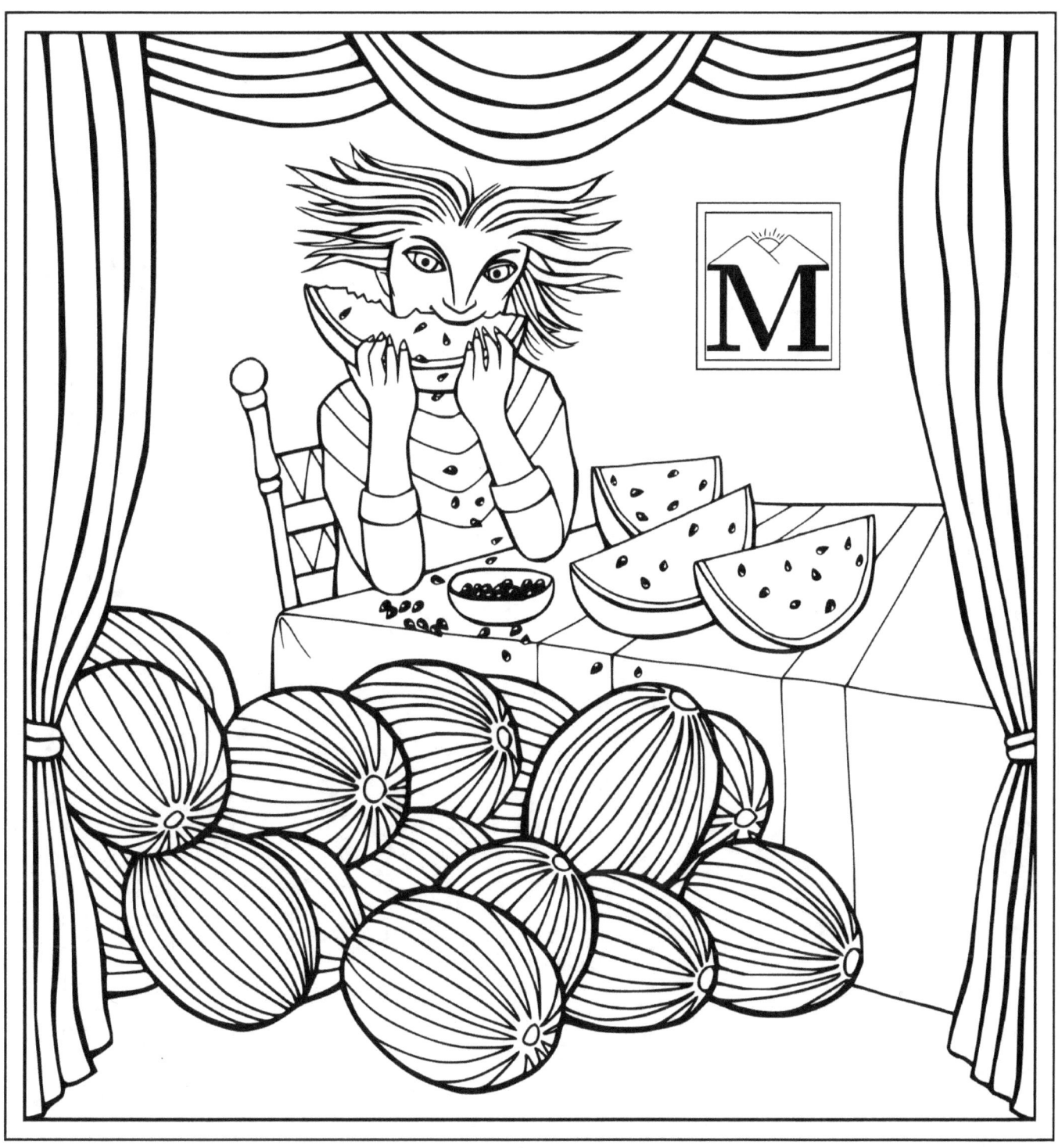

mellow : pleasantly smooth and free of harshness

Nimble Nina nabbed a nest of newborn nenes.

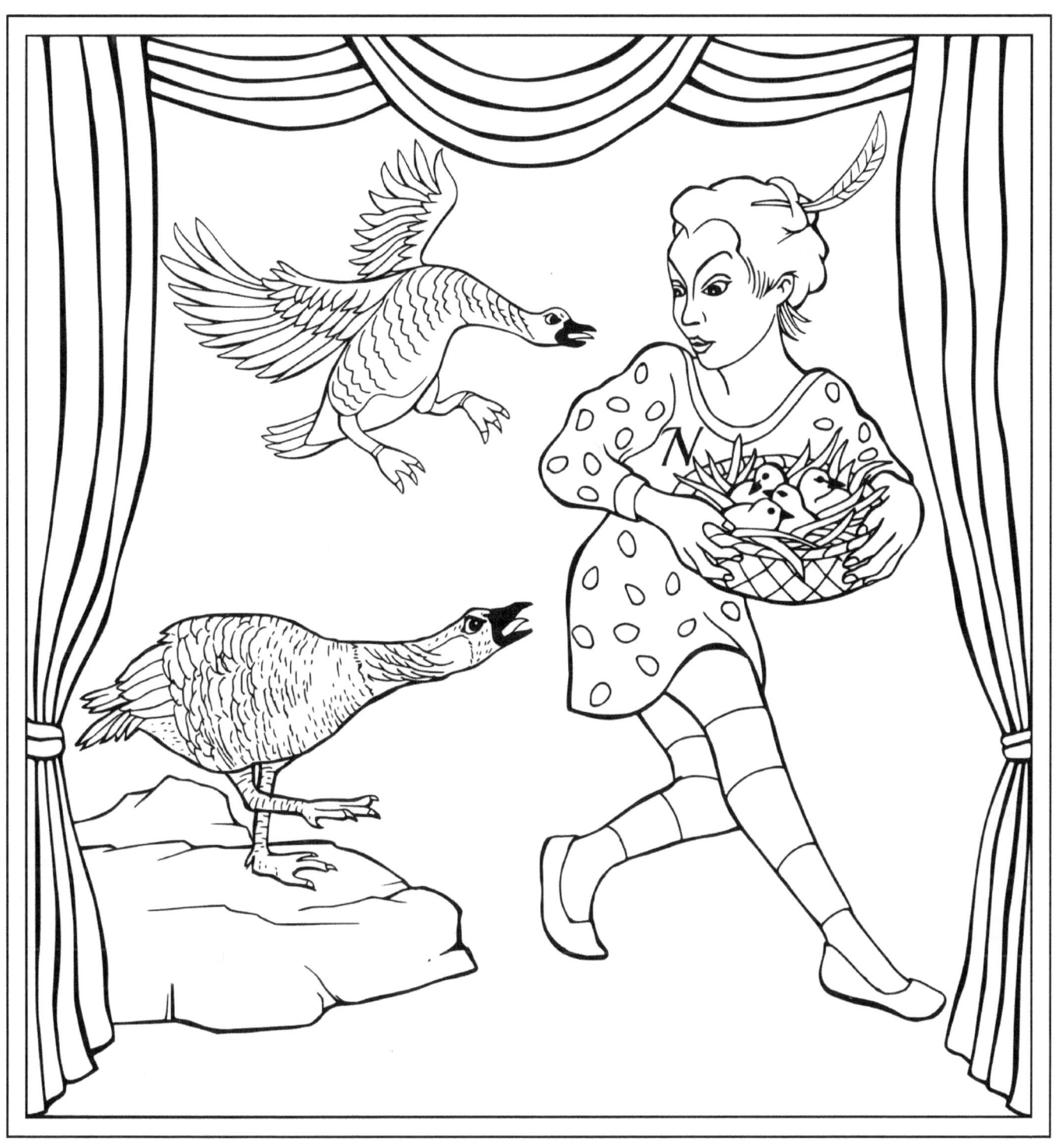

nenes (pronounced "nay-nays") : rare wild geese of the Hawaiian Islands.
The nene is the state bird of Hawaii.

Owlish Oscar oiled oodles of oozing oysters.

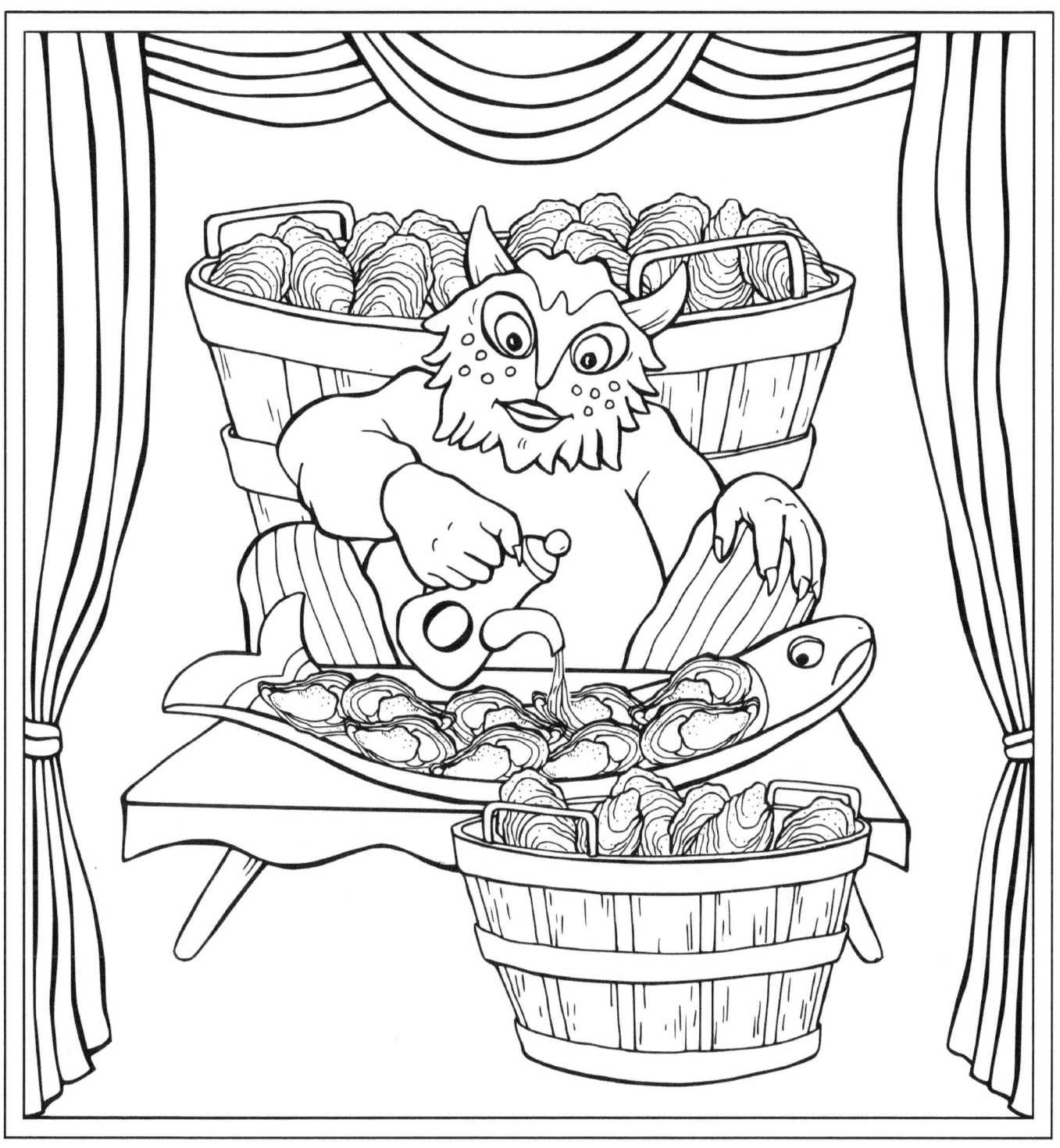

owlish : like an owl, appearing wise or solemn

Paunchy Peter patched a pair of painted puffins.

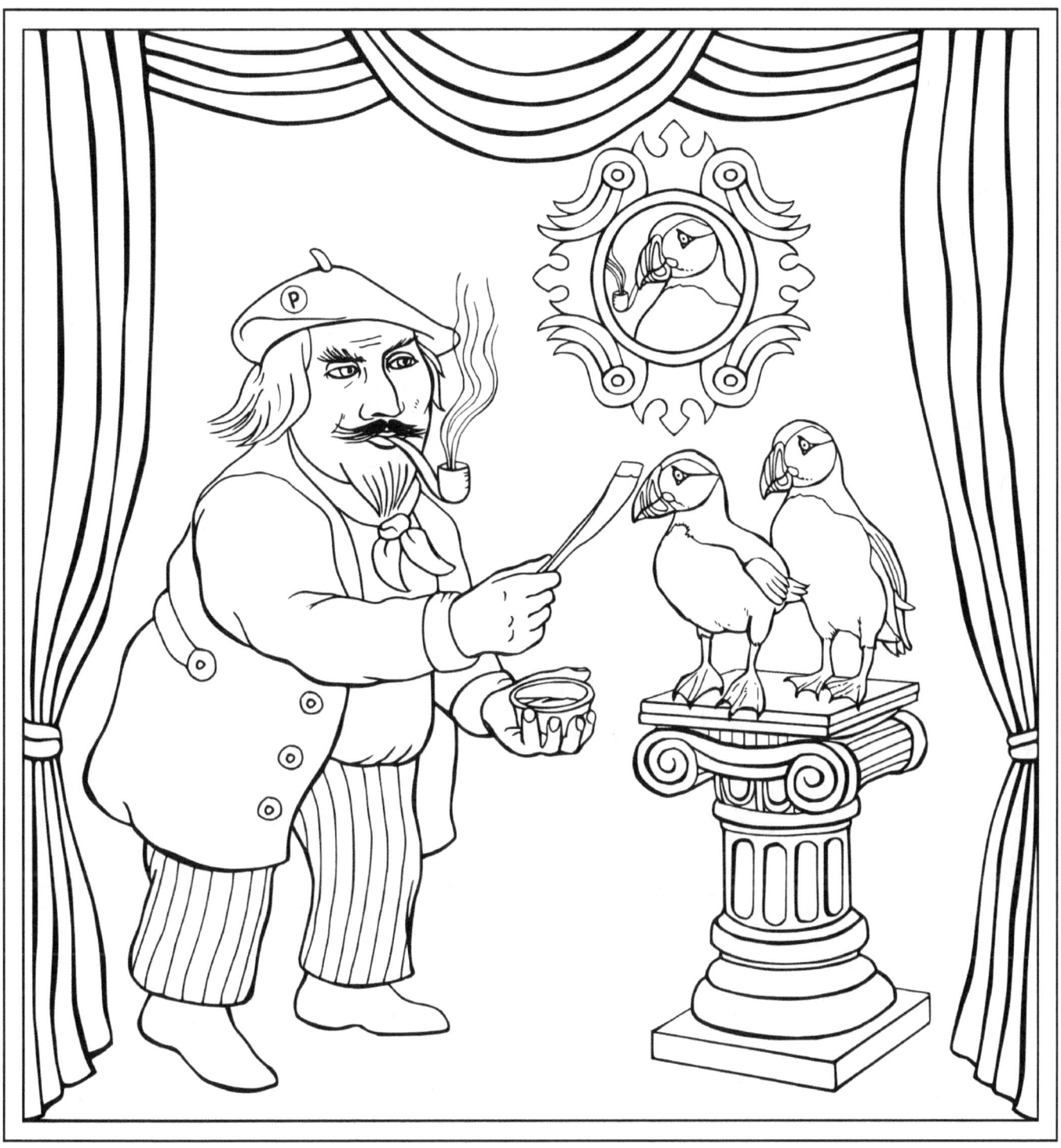

paunchy : having a potbelly
puffins : short-necked sea birds with black and white feathers and a triangular bill

Quirky Quincy quizzed the queen of quaking quokkas.

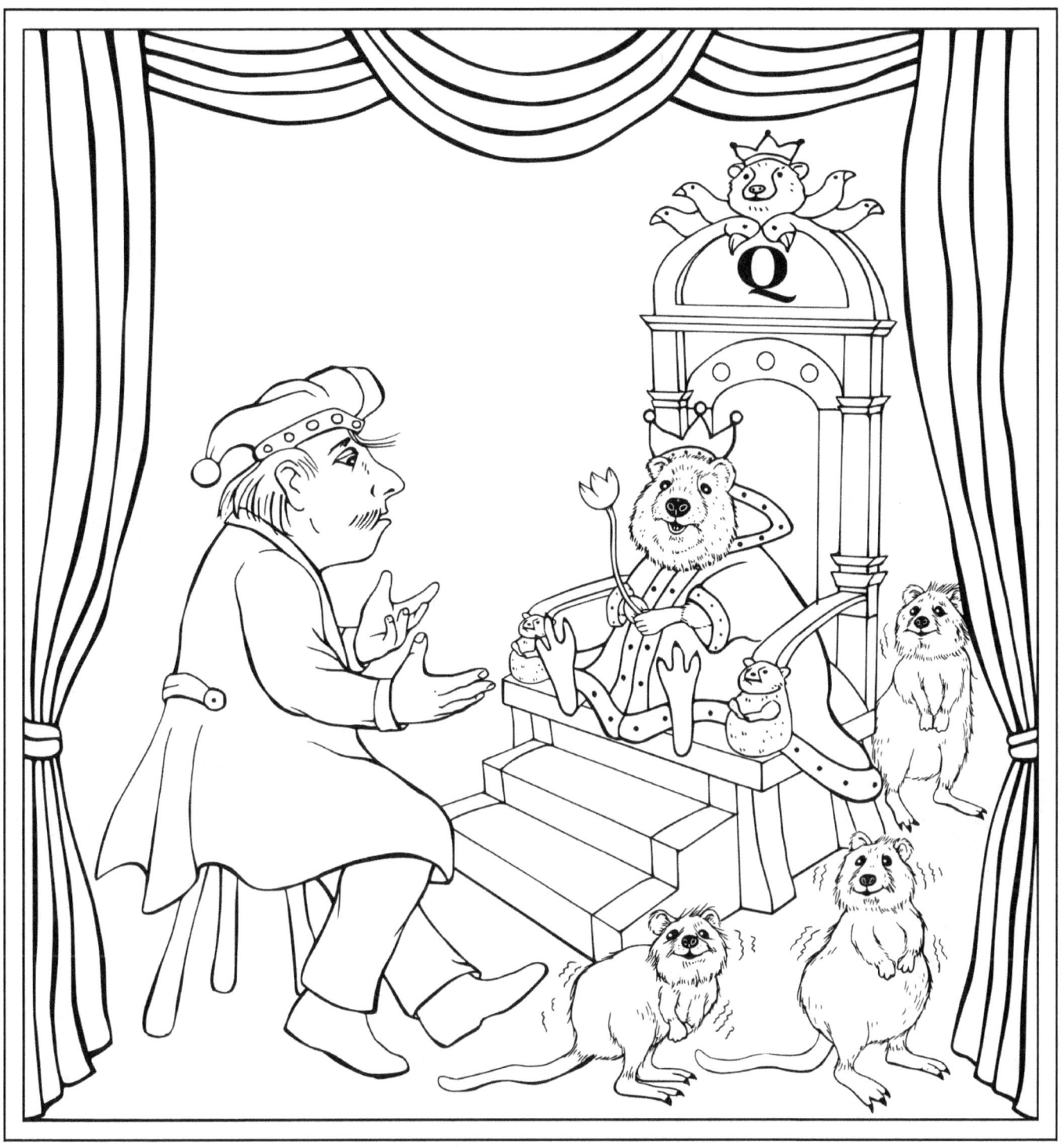

quirky : unpredictable; hard to explain
quokkas : small, short-tailed wallabies from the coastal areas of southwest Australia.
The wallaby is related to the kangaroo.

Rowdy Rupert rode a raft of rhyming rhinos.

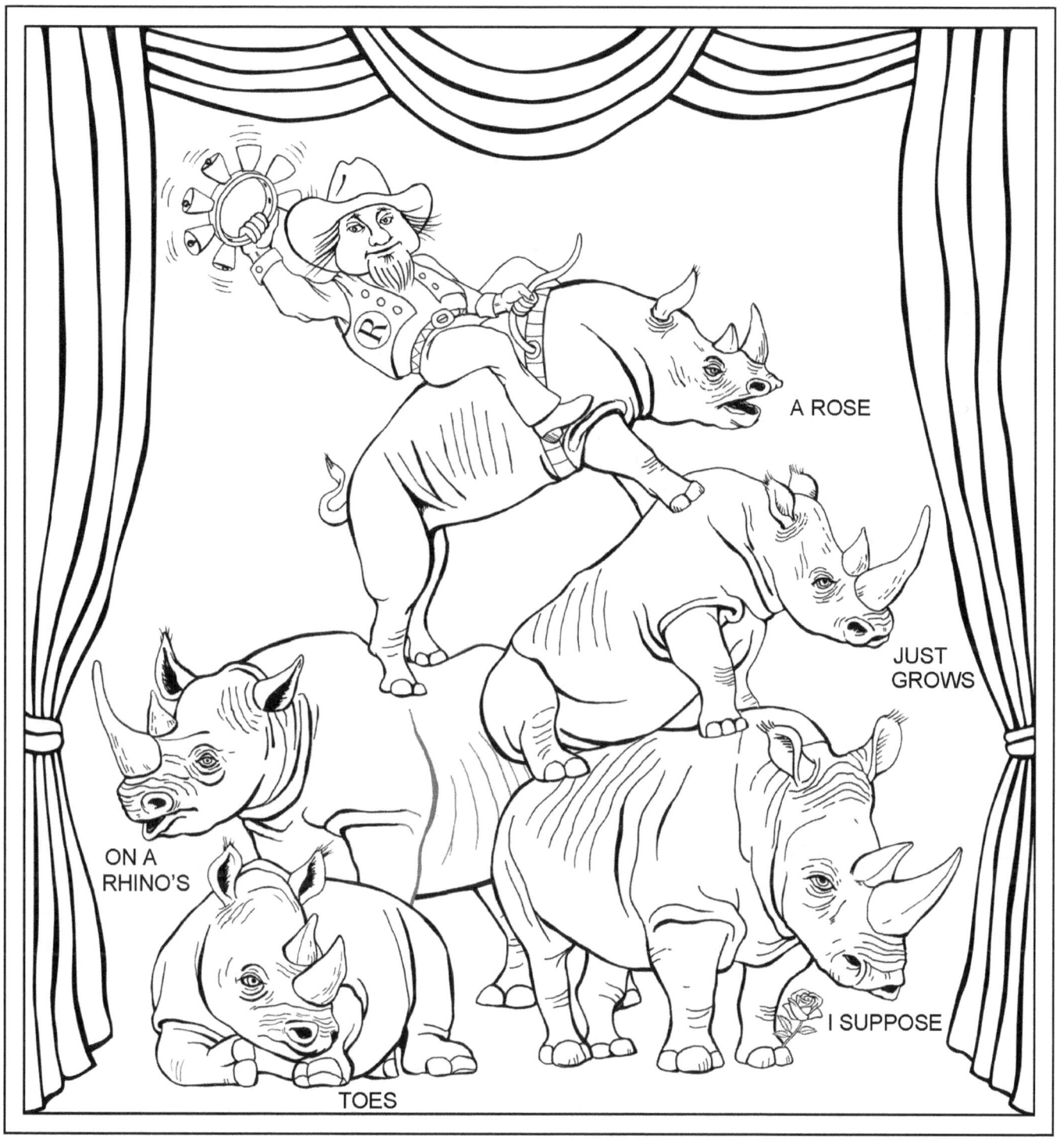

rowdy : rough and disorderly
a raft of : a large number of

Strumming Sally sang a song of squids and sea slugs.

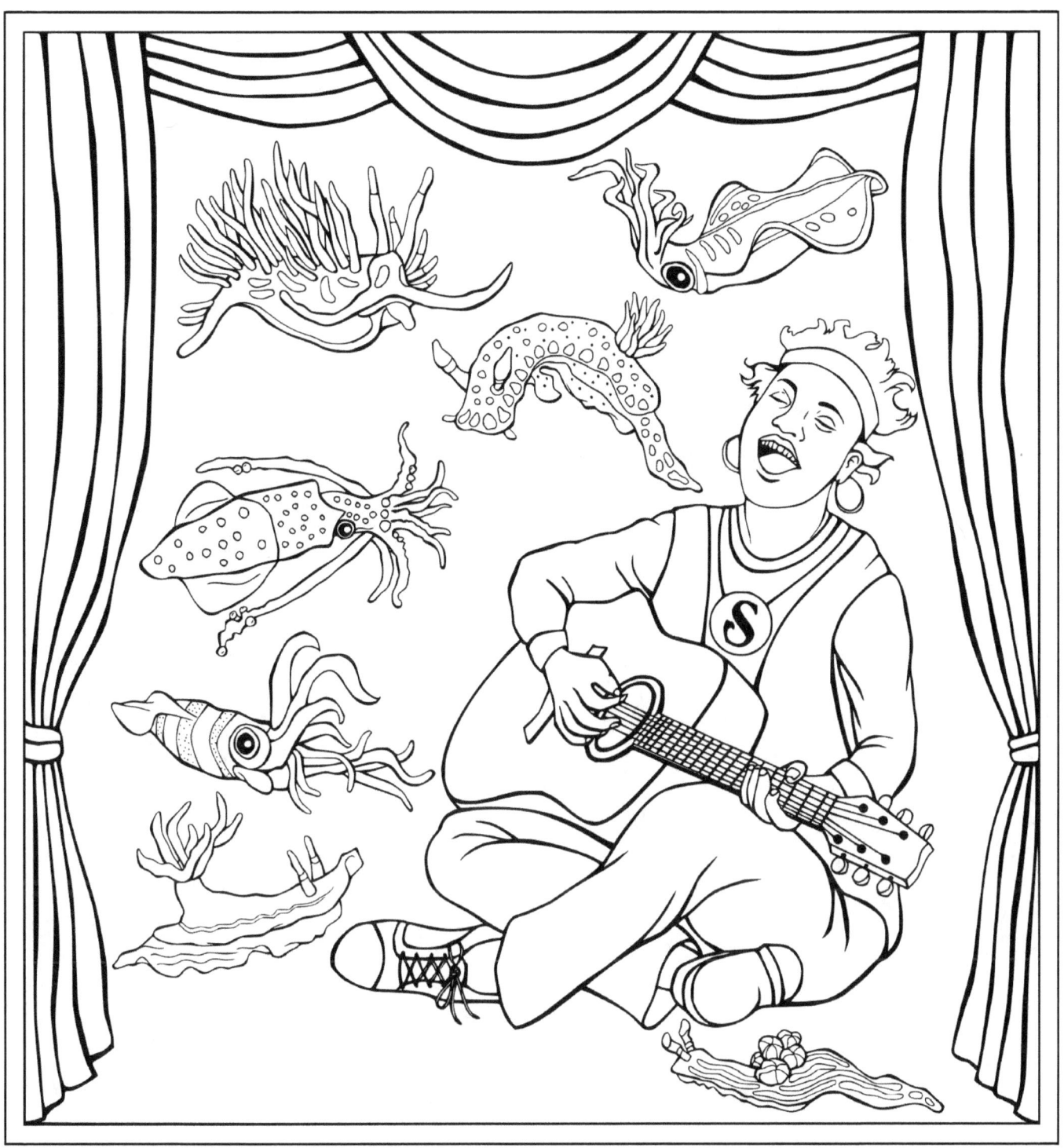

<u>strumming</u> : playing a stringed instrument by using the fingers or thumb to stroke the strings
<u>squids</u> : sea creatures with a long soft body, tentacles, and large eyes, related to octopuses. Squids can change colors.
<u>sea slugs</u> : brightly colored soft-bodied marine animals with many appendages on their top side

Tiny Tina trained a troupe of tattooed tapirs.

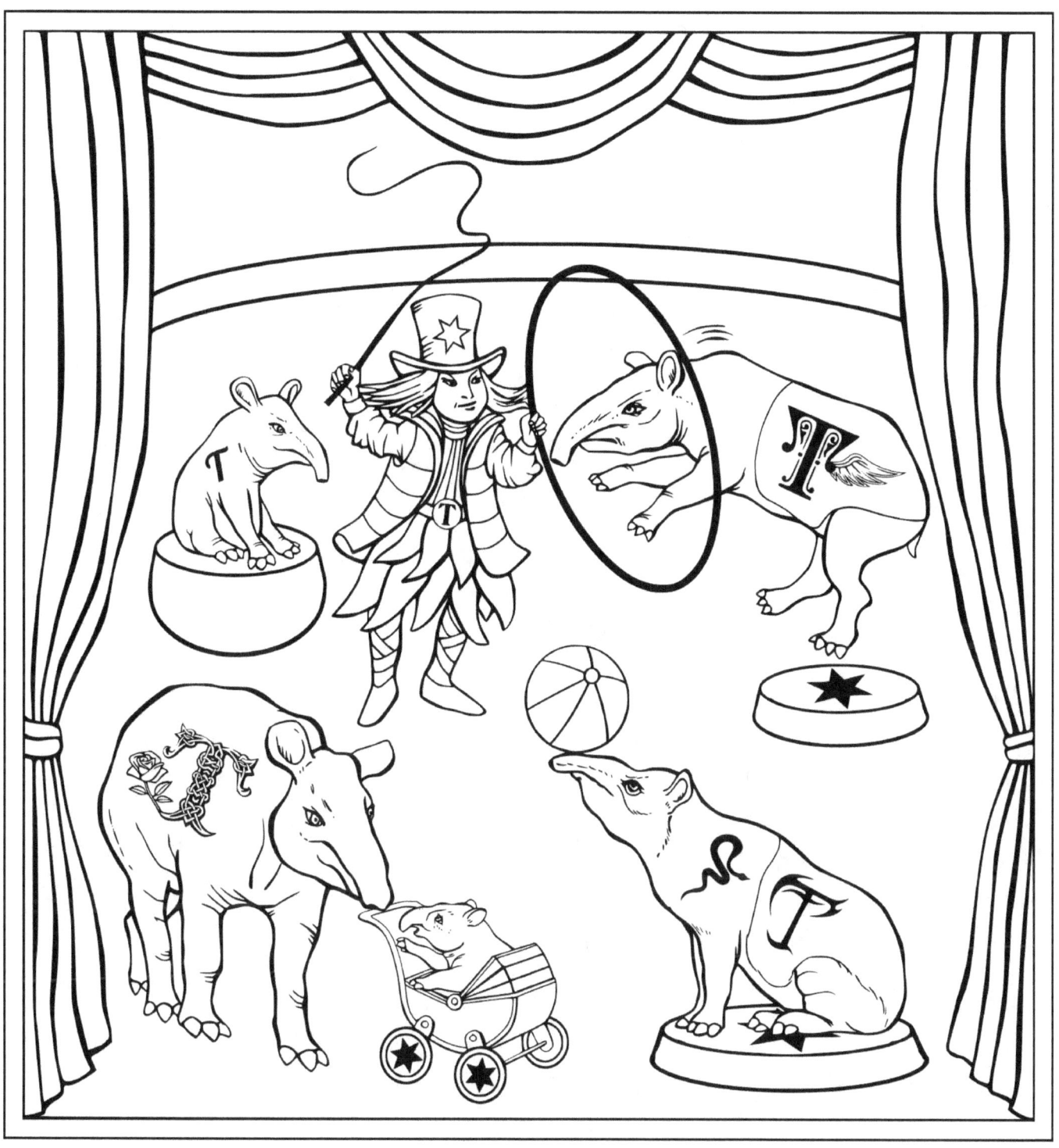

troupe : a group of entertainers who move from place to place

tapirs : large animals with short legs, a heavy body, and a long fleshy snout. They are plant eaters, good swimmers, and can walk on the bottom of a river like a hippo.

Uncle Uno urged a unicycling unicorn.

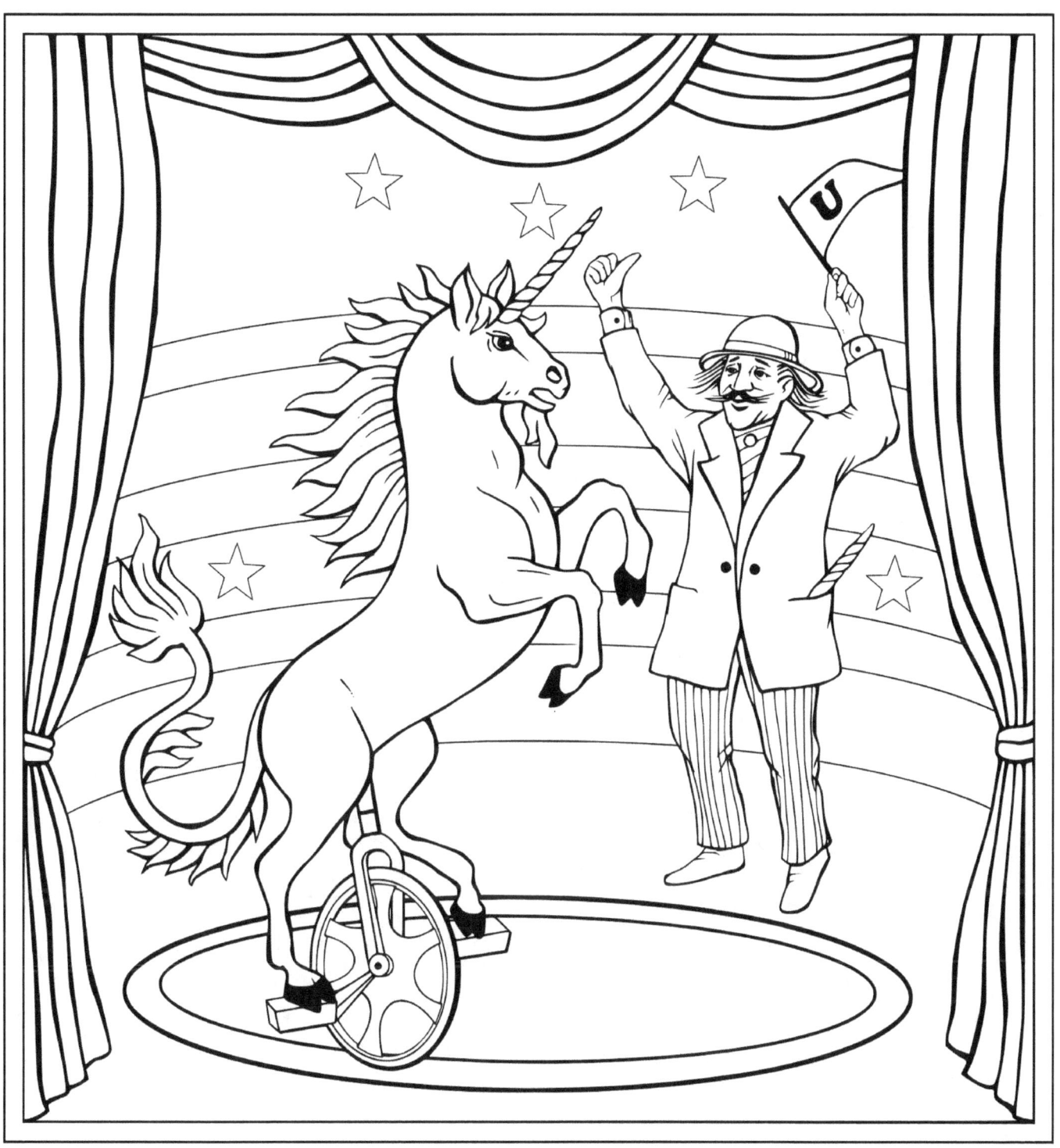

urged : spurred on or encouraged, especially by cheers and shouts
unicycling : pedaling a single-wheeled vehicle while keeping your balance
unicorn : legendary creature with a single large, pointed, spiraling horn projecting from its forehead. In folklore, the unicorn is often depicted as a white horse-like or goat-like animal with a long horn and cloven hooves (and sometimes a goat's beard).

Valiant Vera vaulted vats of vicious vipers.

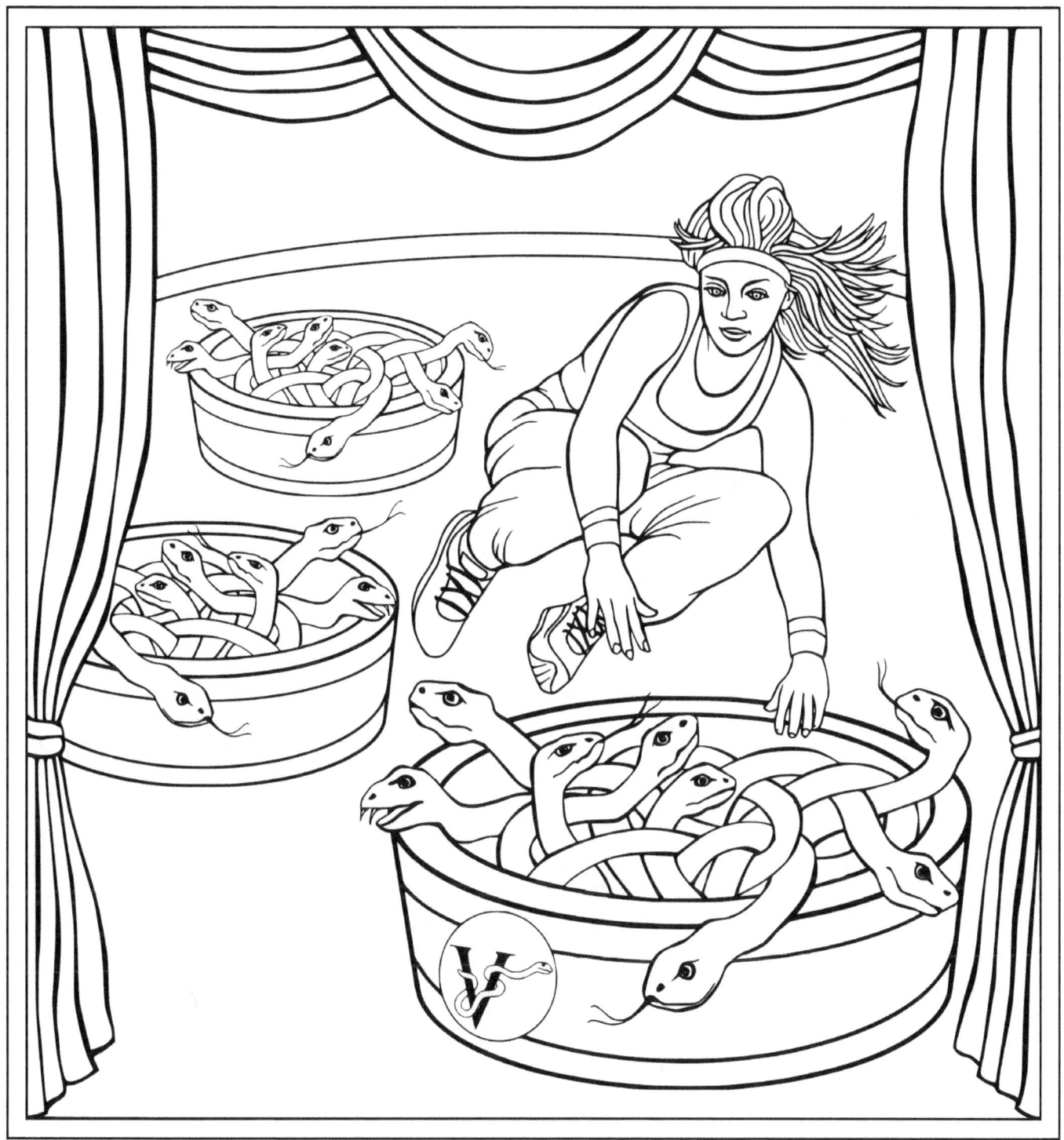

valiant : courageous and determined
vaulted : leapt over while propelling oneself with one or both hands or a pole
vats : tanks or tubs usually used to hold liquid
vipers : thick-bodied poisonous snakes

Wacky Wanda wiggled her warthog's woolly wig.

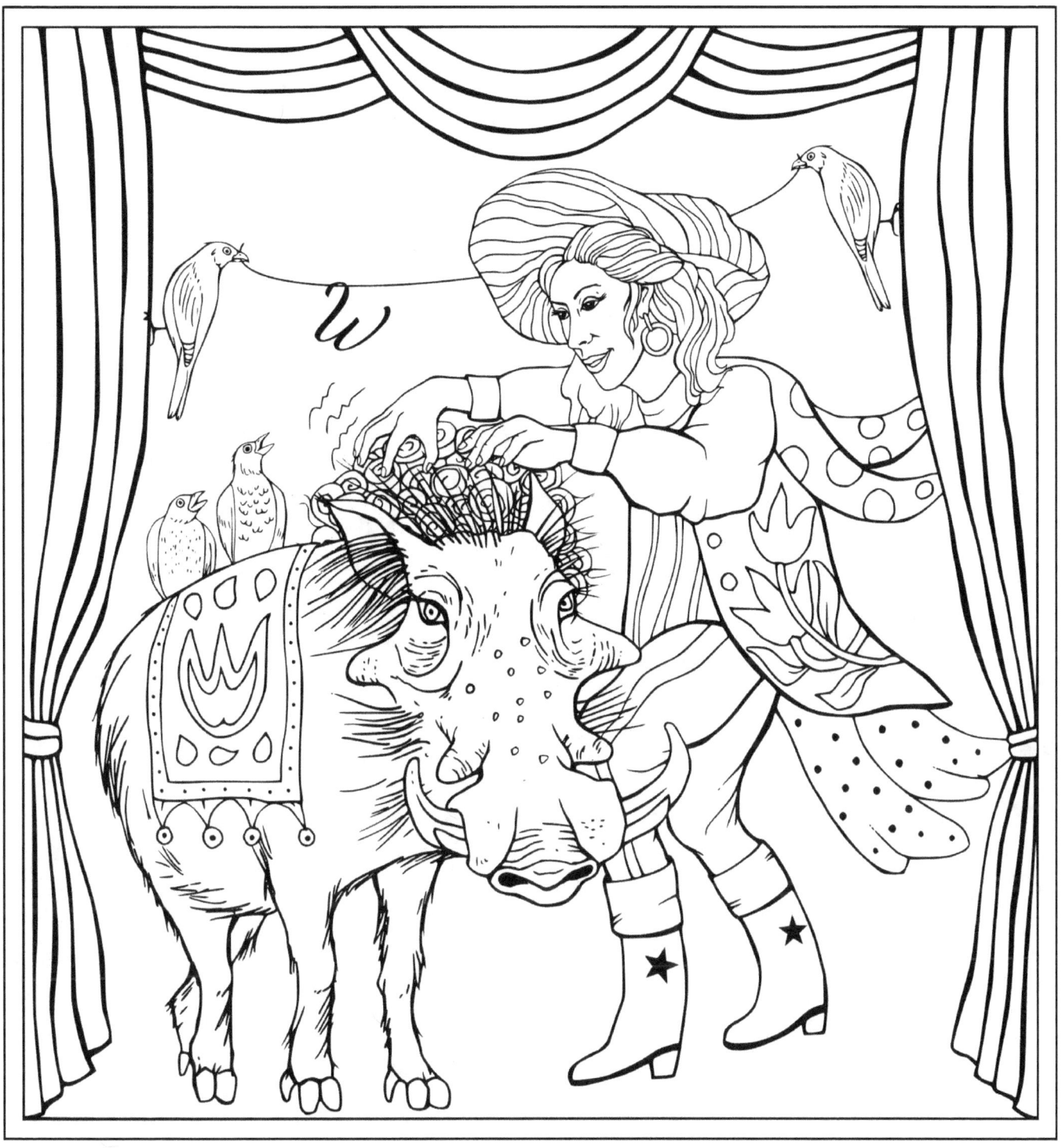

wacky : amusingly odd or peculiar

warthog : an African wild pig with bristly skin, a large head, warty lumps on the face, and curved tusks

Xavier X-rayed an exotic xenurus.

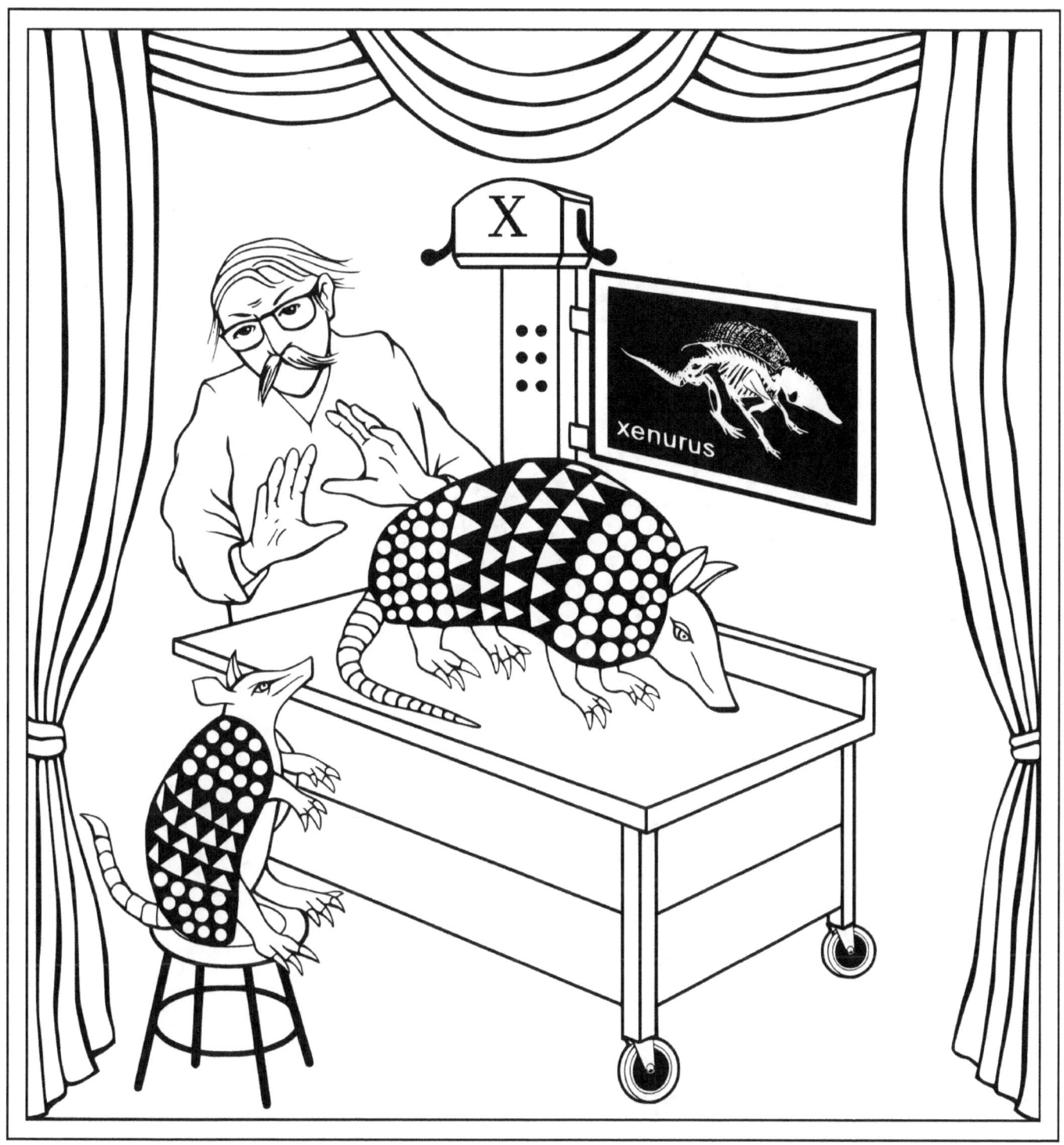

exotic : strikingly, excitingly, or mysteriously different or unusual

xenurus : an armadillo from the Brazilian tropics. It has a long head, round tapered tail, and large claws on its front feet.

Yawning Yancy yanked the young yak's yellow yo-yo.

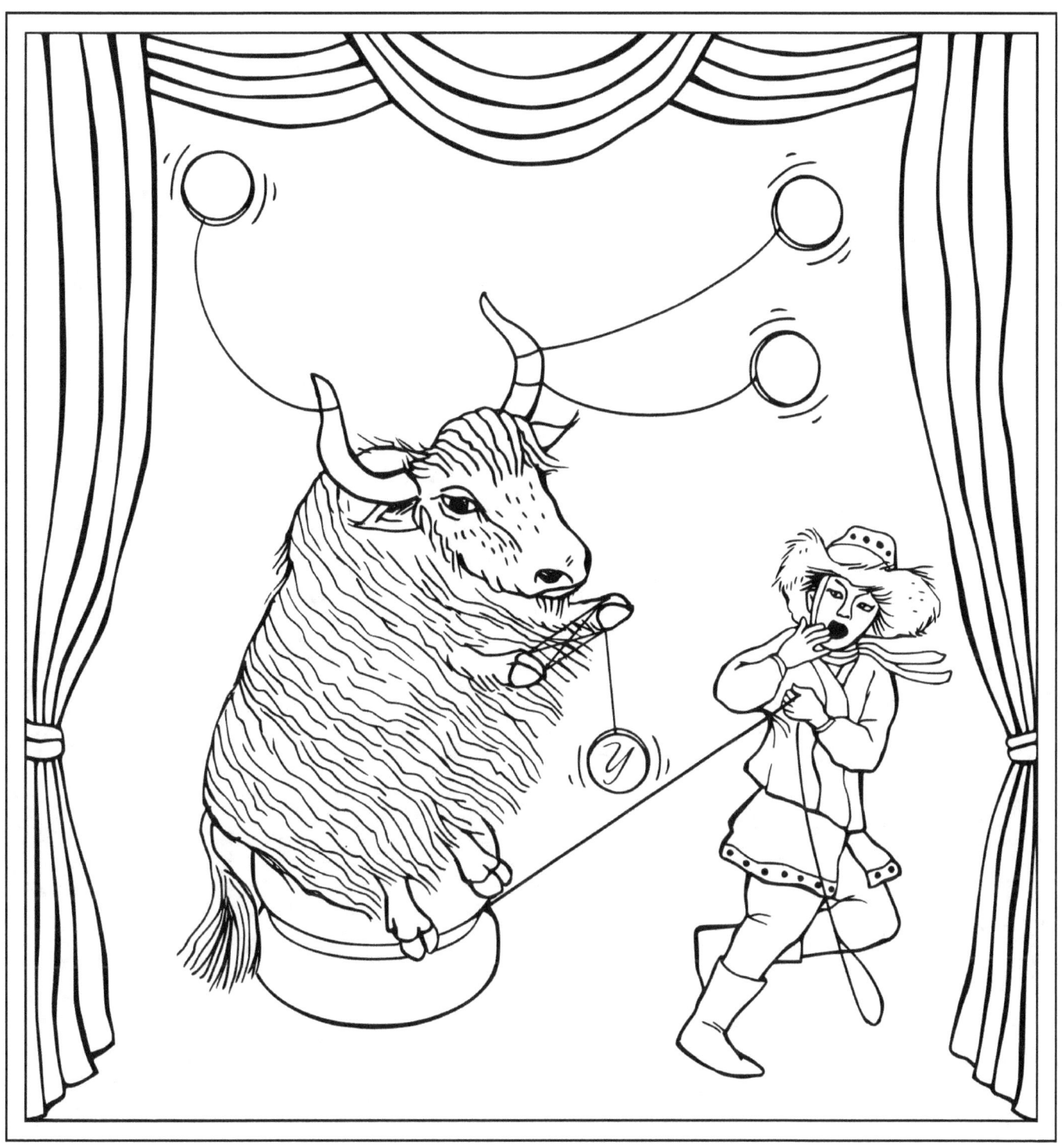

yak : a large domesticated wild ox with shaggy hair, humped shoulders, and large horns, used in Tibet as a pack animal and for its milk, meat, and hide

Zany Zelda zapped zebras on a ziggurat.

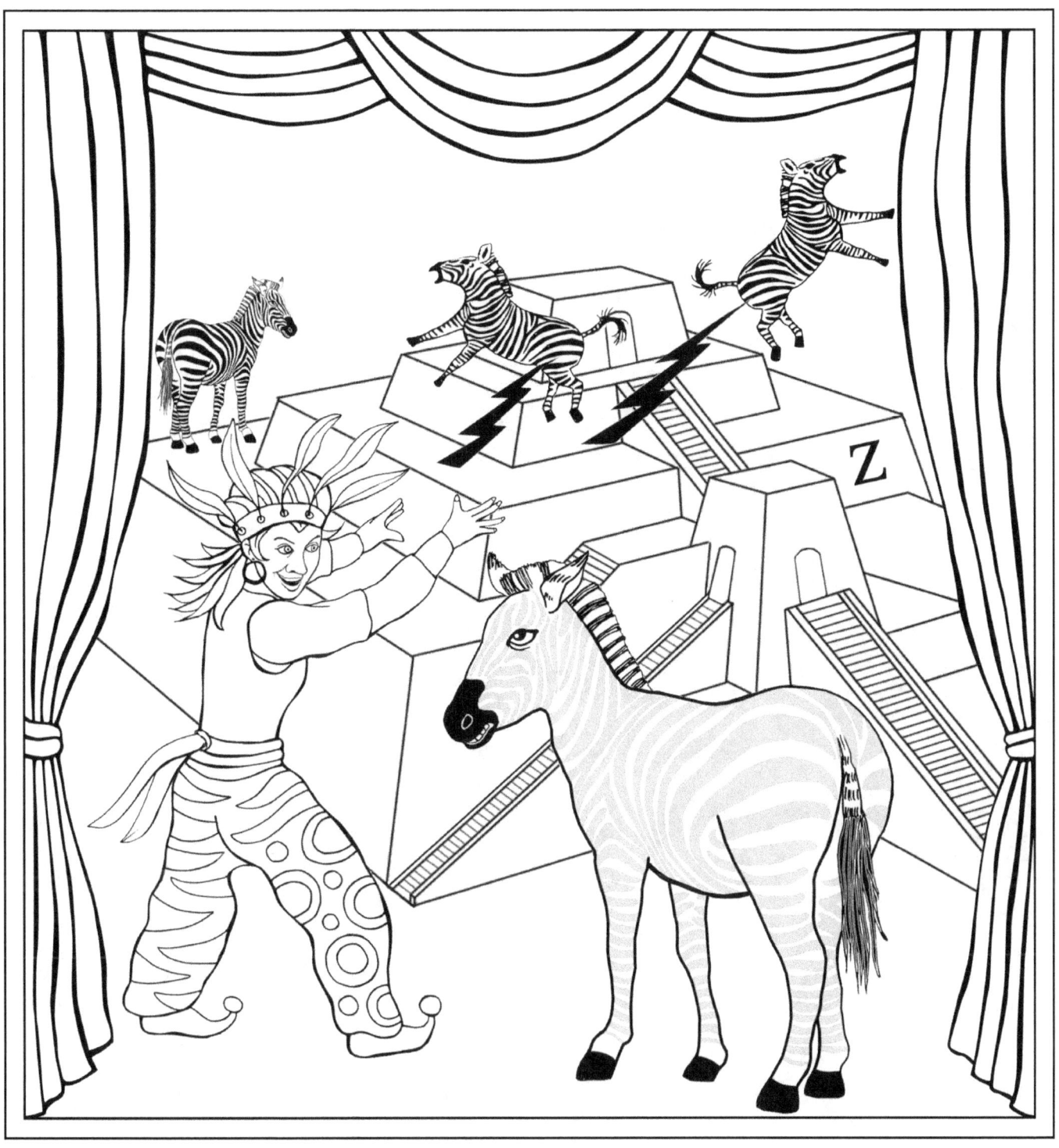

zany : clownishly comical

ziggurat : huge ancient pyramid-like structure built in stacked levels of decreasing sizes. The different levels were connected by outside stairs.

www.ingramcontent.com/pod-product-compliance
Lightning Source LLC
Chambersburg PA
CBHW060005230526
45472CB00008B/1960